CW01022790

CHILDE HASSAM

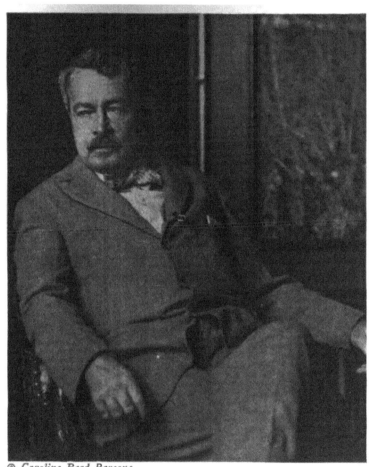

CHILDE HASSAM

CHILDE
HASSAM

Compiled by
NATHANIEL
POUSETTE-DART
With an introduction by Ernest Haskell

NEW YORK
FREDERICK A. STOKES COMPANY
PUBLISHERS

CHILDE HASSAM

CHILDE HASSAM'S heritage, his Puritan ancestry, with the downright qualities that such ancestry engenders, has had much to do in shaping his career. He was born in Boston in 1859, with an American ancestry dating back to 1631, when his forbears settled in Dorchester. This is indeed a sturdy background, for the force that was needful in Puritan conviction can be transposed very easily into artistic effort. And as one will find that from Whistler's forbears in Lowell a great artistic force found something to lean upon, so these ancestors of Childe Hassam have given him that intangible something, that very personal individual force, that stamps things indelibly.

Bred into his art is this vigorous quality, this New England thoroughness. And how essentially American his work is! He has absorbed the European influence of his younger days and stands alone profoundly American. This "national integrity" is without doubt the great need of American art to-day. This quality in the case of Hassam seems his birthright, for he is a Puritan.

The masculine quality in Hassam's work is to be observed. One is conscious that the work is the outcome of vigor that is not afraid to confront the elements. The connection between the picture and subject seems most direct. They are not so-called studio pictures. He paints in the open. So many of his pictures have taken great physical effort to execute, yet one never finds signs of

druagery. He loses the signs of labor in the joyful brush-work in which he is unequalled. These are qualities of the master.

He has a way of taking his own where he finds it, and thus he leaves the stamp of his personality on localities where he has worked. Take Gloucester for example. Before I had seen Hassam's pictures, it seemed a fishy little city, now as I pass through it I feel Hassam. The schooners beating in and out, the wharves, the sea, the sky, these belong to Hassam. Just as one cannot go to Venice and be very far from Whistler. There are many other spots that he has made his own: but one of these in great contrast to Gloucester is Fifth Avenue. This street he has done at various times, and over a long period. Back in the days when hansom cabs and victorias were in evidence, then with the automobile, precisely mechanical, traffic congested, and with racial crowds of the clothing shops. The most daring effort was to paint the Flags. No one had ever painted flags before, so now when one thinks of flags one thinks of Hassam's flag pictures. These pictures were not garish affairs but were filled with the poetry of patriotism. He made the Flags symbols of his heritage. Only a Puritan could have painted flags as he did.

There are many other fields that he has invaded and made his. Flowers in gardens, flowers in still life, flowers as accessories to portraits. These are painted with great tenderness, great restraint of color yet very colorfully, always part of the picture, never jumping out in forced contrast. Interiors are his,—interiors that are renderings of space with a magic play of light, the light that instinc-tively seems to be the heritage of Hassam. From a cool room through a Dutch door is a light, warm, out-of-doors

—with all the characteristics held in restraint. One feels the joy that must have been his in these fine performances.

Then there are doorways of the days of long ago. Colonial doorways of rare proportion, and these are choicely done quite as skillfully as the other pictures, for Hassam is no specialist. Village streets with hot sun and cool shadow, elms that are elms with slow-moving wind-swayed tops. You feel the street, and you feel the elms, you feel the quality of the objects portrayed.

Hassam feels very keenly what he does. The approach is never languid—there is a sharp decision made in his mind at each stroke of the brush. This tends to carry his impression home very forcibly, and gives the passages that crisp fresh living quality.

His etching interests me deeply, for I know how difficult the mastery of this great art is, especially to the artist whose habit has been in the field of color. It requires linear perception and an utter absence of fear towards the medium which is really formidable, for the uncompromising copper and steel point are not very sympathetic. What Hassam has done in etching is very remarkable. In less than a decade he has become an etcher. His etchings are as individual as are his paintings.

He had things to express and he expressed them in his own manner, without fear of his medium. Etching is a test of an artist's ability for in this precise method his weaknesses are revealed. Hassam took the most difficult course. He drew the plates cleanly letting each line remain to tell its story. He then printed the plates as few etchers dare to print, namely, with a clean wipe. This method reveals all to the experienced collector of prints. Nothing is hidden by false surface ink.

Hassam's lithographs are another triumph. Not heavy

crudities with impossible black smudges as are so many efforts of our modern lithographers: but light crisp renderings of fearless decision. Whistler was right. A lithograph should be "blonde."

The real Hassam will never be found in written eulogy —but in his pictures. Go to them, observe them carefully and then you will find what cannot be described, that intangible something, the charm of the true artist. Hassam is a Puritan and he paints American pictures—and furthermore Hassam is himself.

ERNEST HASKELL.

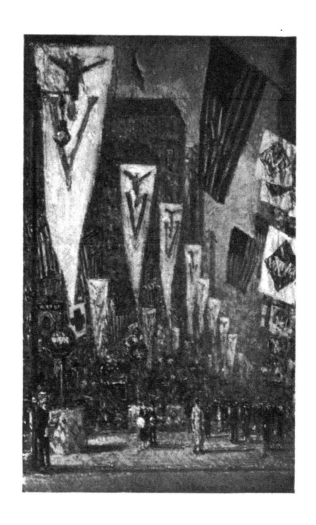

VICTORY WON
On view at the Milch Galleries

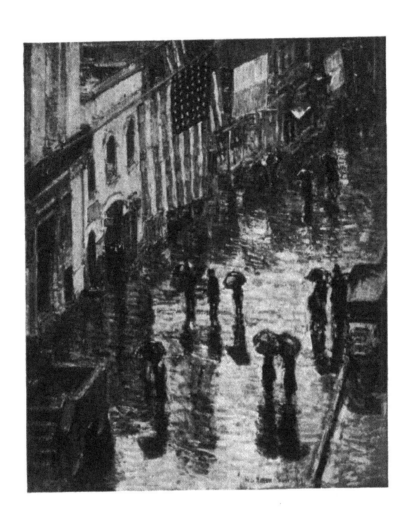

ST. PATRICK'S DAY—1919
On view at Milch Galleries

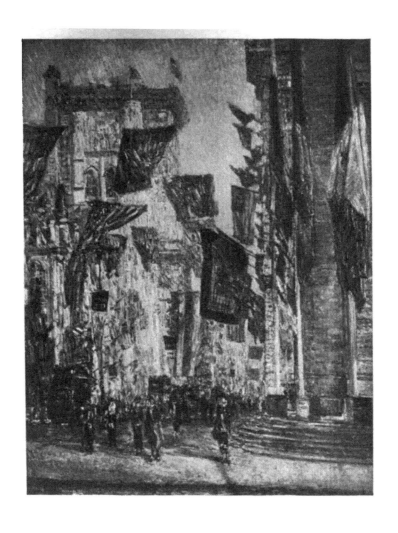

AVENUE OF THE ALLIES, ST. PATRICK'S CATHEDRAL
On view at Milch Galleries

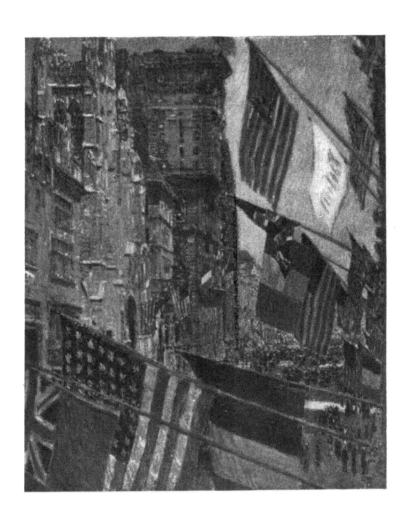

ALLIES DAY
Owned by Gilbert E. Rubens, New York City

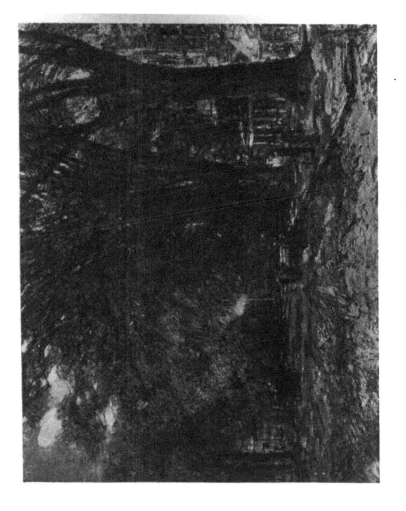

MAIN STREET, EAST HAMPTON
Property of Wm. Macbeth, Inc.

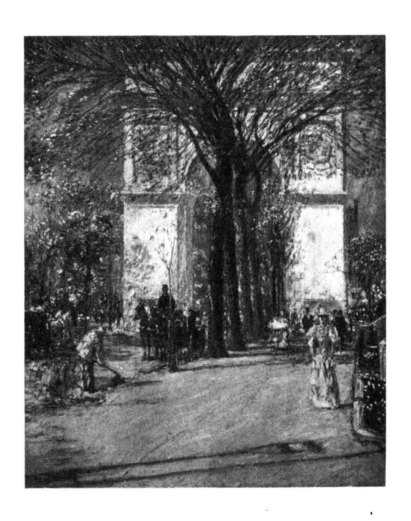

WASHINGTON ARCH
Owned by Duncan Phillips, Washington, D. C.

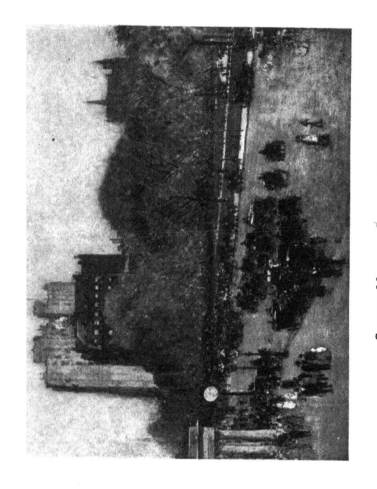

SPRING, MADISON SQUARE, 1890
Owned by G. F. McKinney

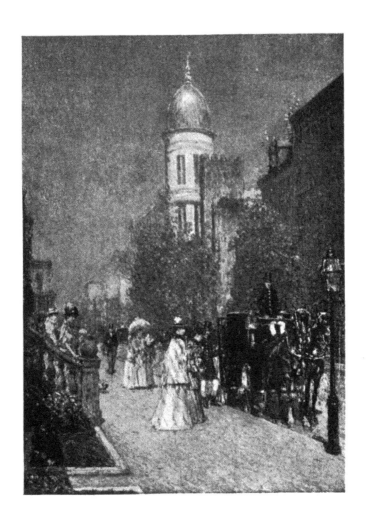

SPRING-TIME—WEST TWENTY-SECOND STREET
Owned by Mrs. J. A. Cullen, New York City

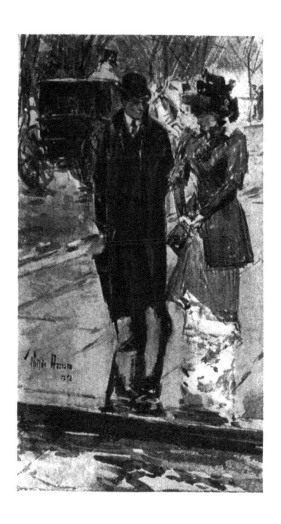

RAINY DAY
(Water color)
On view at Milch Galleries

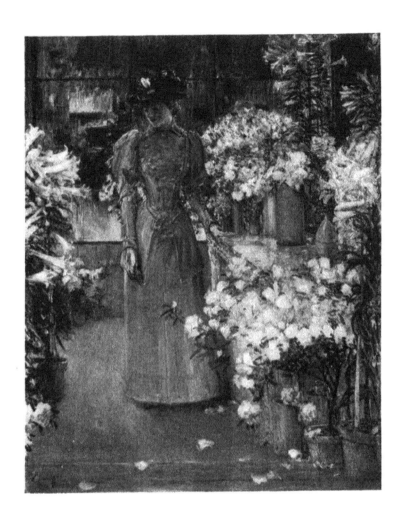

THE LITTLE FLOWER SHOP
On view at Milch Galleries

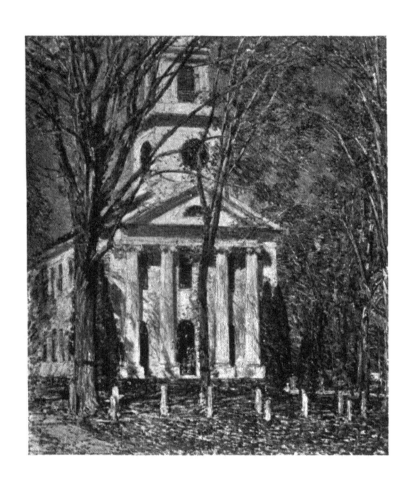

CHURCH AT OLD LYME
Owned by the Albright Gallery, Buffalo

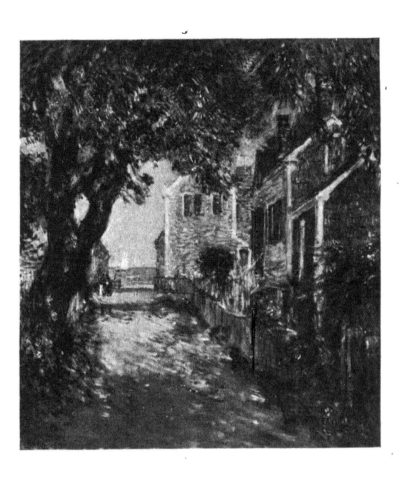

SIDE STREET, PROVINCETOWN
Owned by Alfred R. Hughes, Warren, Ohio

SPRING, MADISON SQUARE, 1890
Owned by G. F. McKinney

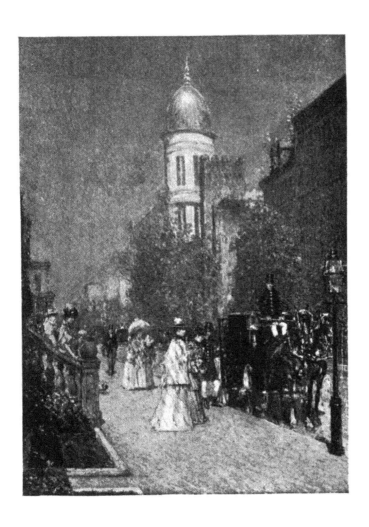

SPRING-TIME—WEST TWENTY-SECOND STREET
Owned by Mrs. J. A. Cullen, New York City

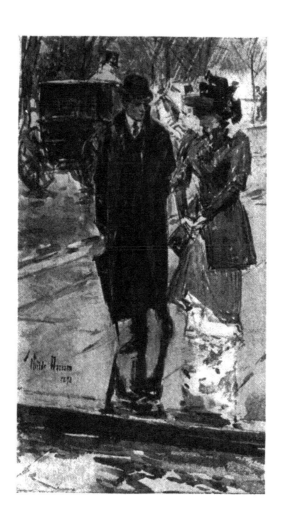

RAINY DAY
(Water color)
On view at Milch Galleries

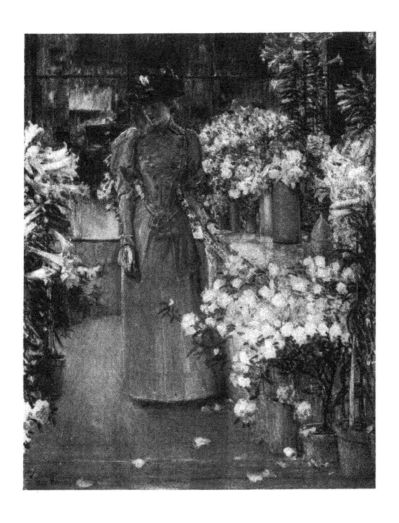

THE LITTLE FLOWER SHOP
On view at Milch Galleries

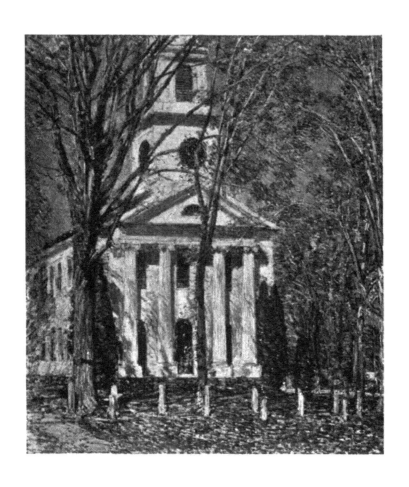

CHURCH AT OLD LYME
Owned by the Albright Gallery, Buffalo

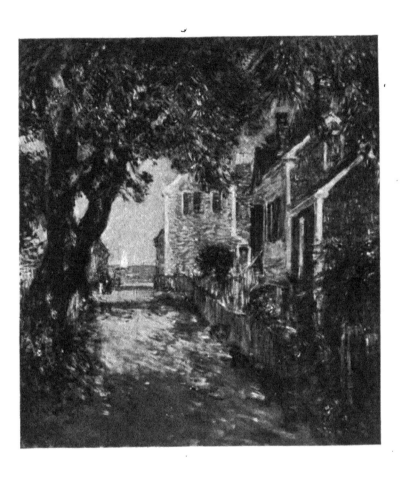

SIDE STREET, PROVINCETOWN
Owned by Alfred R. Hughes, Warren, Ohio

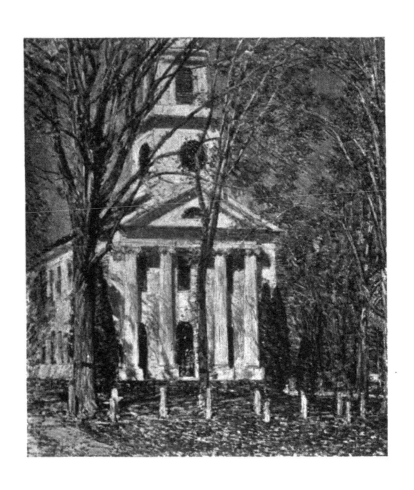

CHURCH AT OLD LYME
Owned by the Albright Gallery, Buffalo

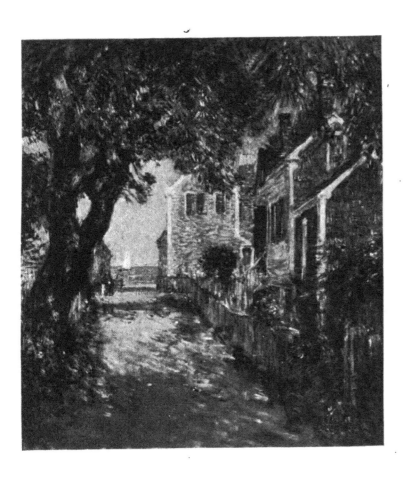

SIDE STREET, PROVINCETOWN
Owned by Alfred R. Hughes, Warren, Ohio

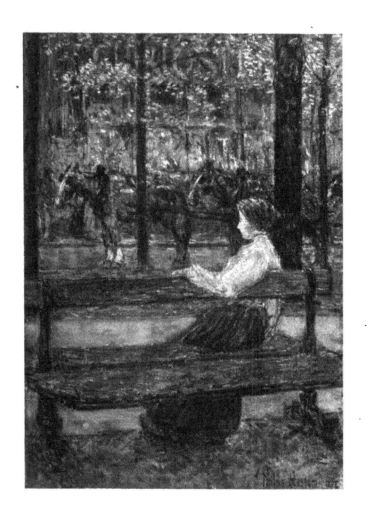

BOULEVARD ROCHECHOUART, PARIS
Owned by the Milch Galleries

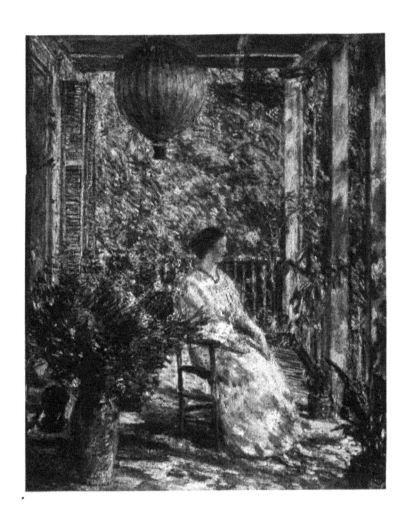

THE PORCH OF THE OLD HOUSE, COS COB
On view at Rehn Galleries

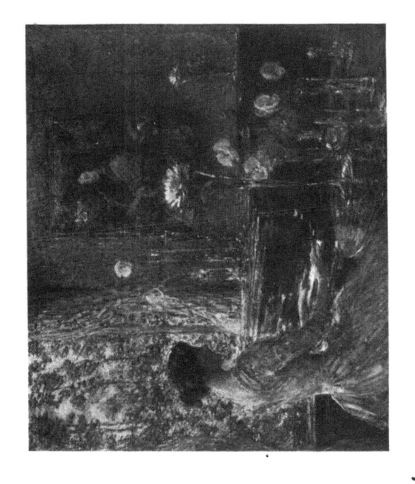

IMPROVISATION

Owned by John Gellatly, Esq., New York City

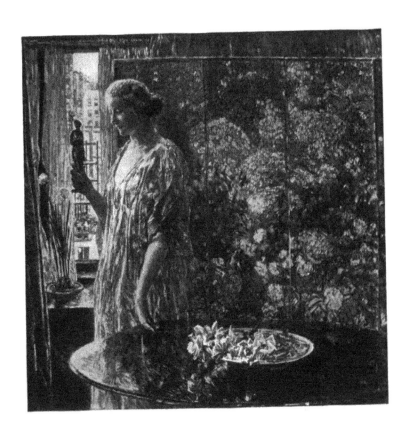

TANAGRA
Owned by John Gellatly, Esq.

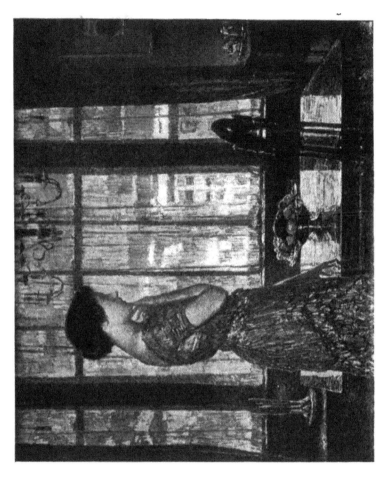

THE NEW YORK WINTER WINDOW
Owned by the artist

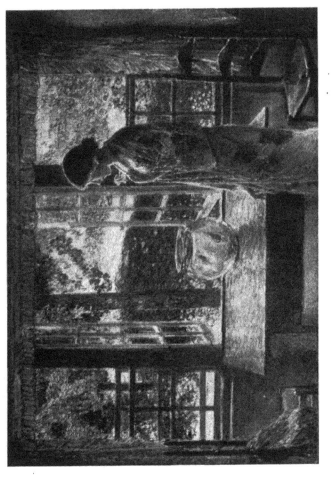

THE GOLD FISH WINDOW
Owned by J. K. Newman, New Orleans

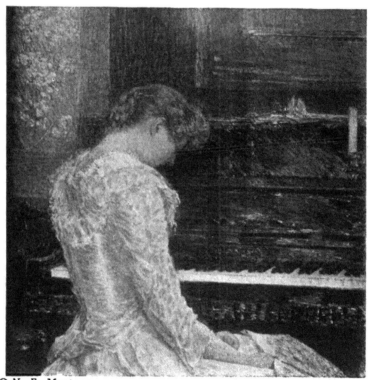

THE MARSHALL NIEL ROSE
Owned by Duncan Phillips, Washington, D. C.

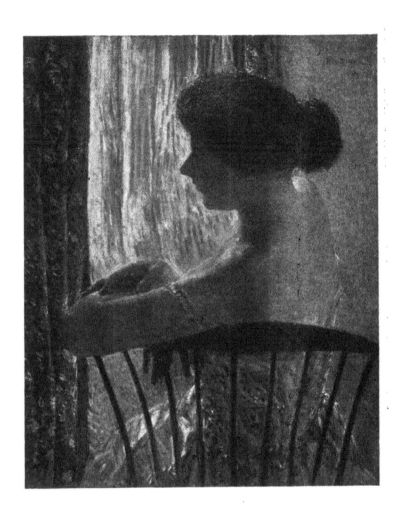

CONTRE-JOUR
Owned by the Art Institute of Chicago

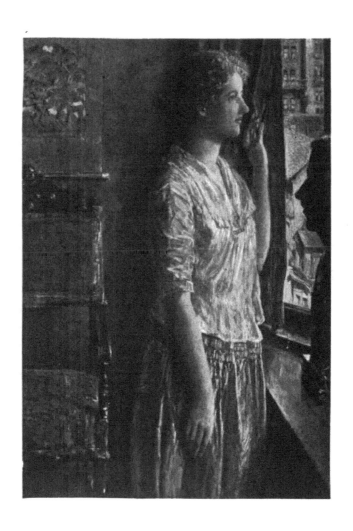

EASTER MORNING
Owned by the artist

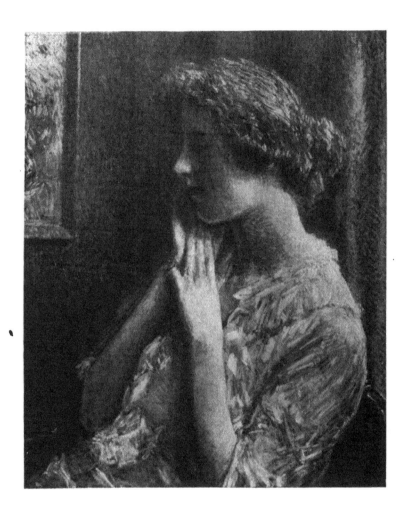

THE ASH BLOND
(Photo taken before painting was finished)
Owned by the artist

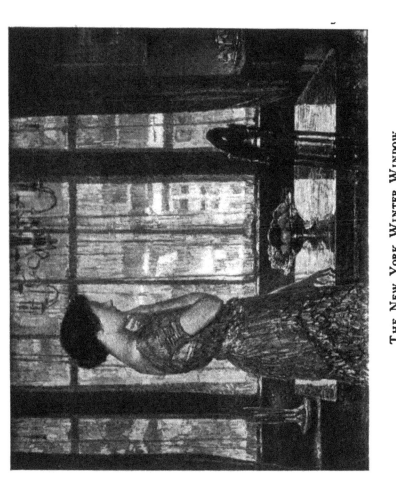

THE NEW YORK WINTER WINDOW
Owned by the artist

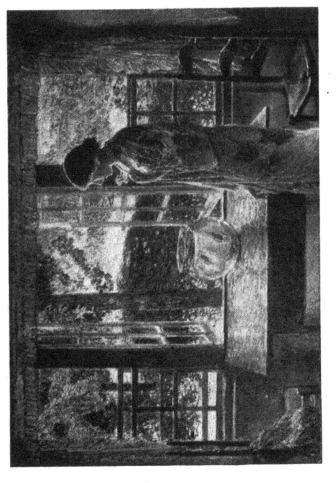

THE GOLD FISH WINDOW
Owned by J. K. Newman, New Orleans

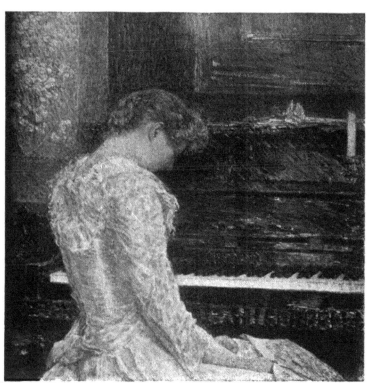

THE MARSHALL NIEL ROSE
Owned by Duncan Phillips, Washington, D. C.

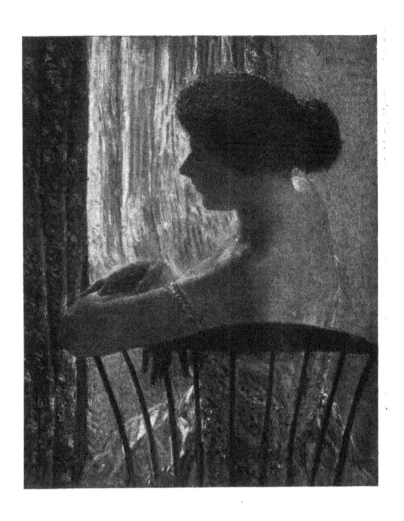

CONTRE-JOUR
Owned by the Art Institute of Chicago

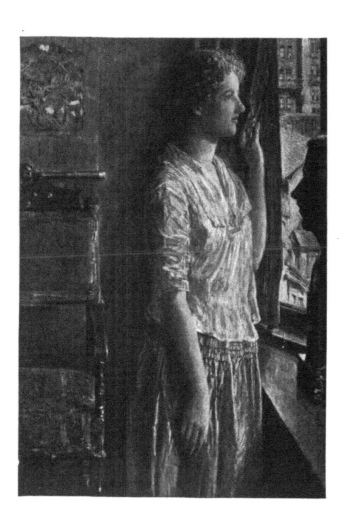

EASTER MORNING
Owned by the artist

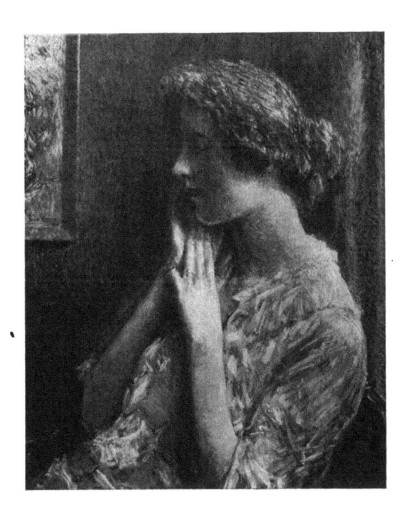

THE ASH BLOND
(Photo taken before painting was finished)
Owned by the artist

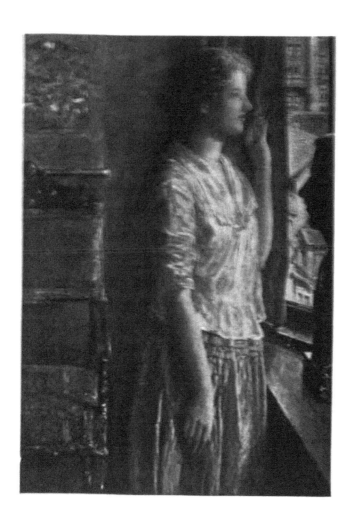

EASTER MORNING
Owned by the artist

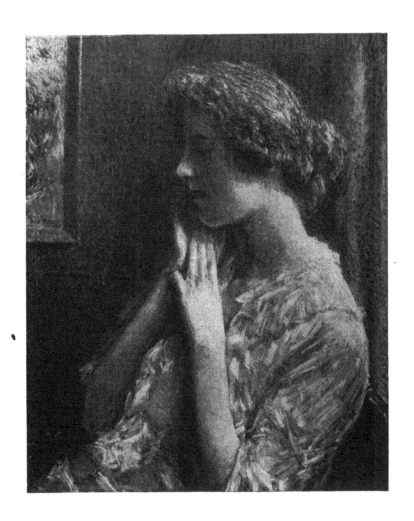

THE ASH BLOND
(Photo taken before painting was finished)
Owned by the artist

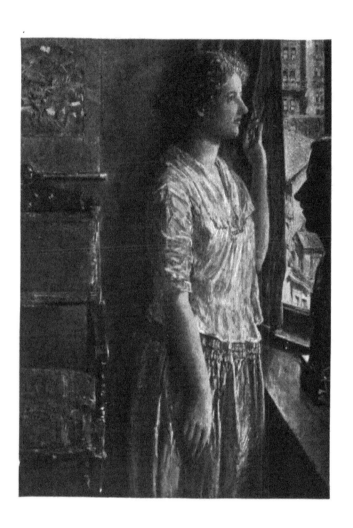

EASTER MORNING
Owned by the artist

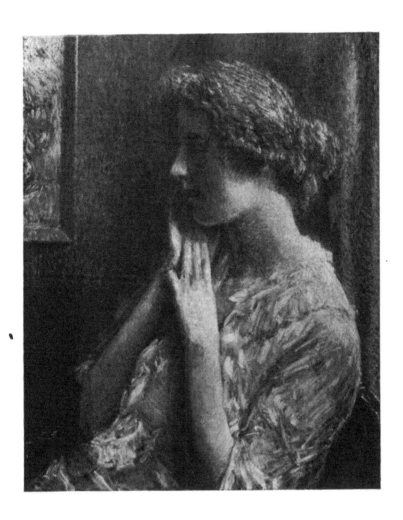

THE ASH BLOND
(Photo taken before painting was finished)
Owned by the artist

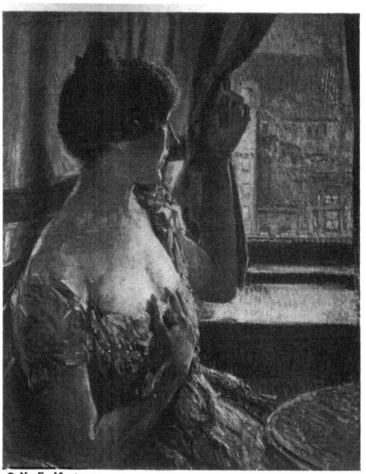

THE 57TH STREET WINDOW
Owned by the artist

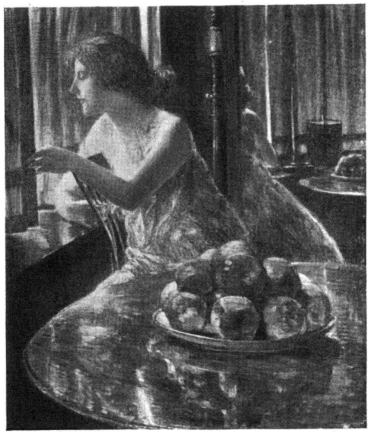

KITTY HUGHES
Owned by Mrs. Marshall Field, Chicago

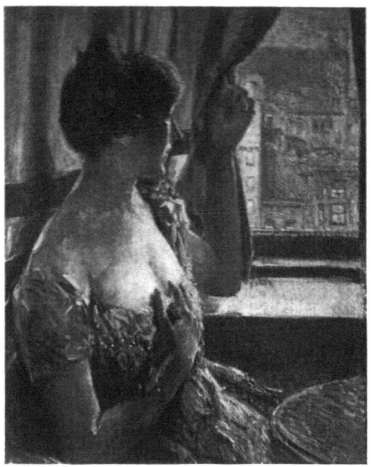

THE 57TH STREET WINDOW
Owned by the artist

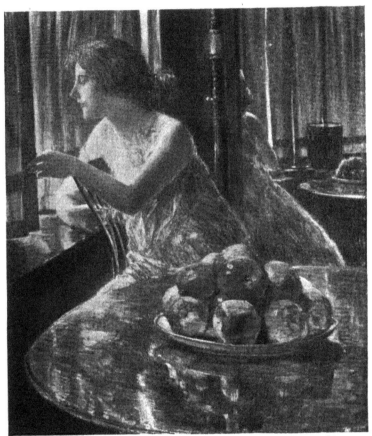

KITTY HUGHES
Owned by Mrs. Marshall Field, Chicago

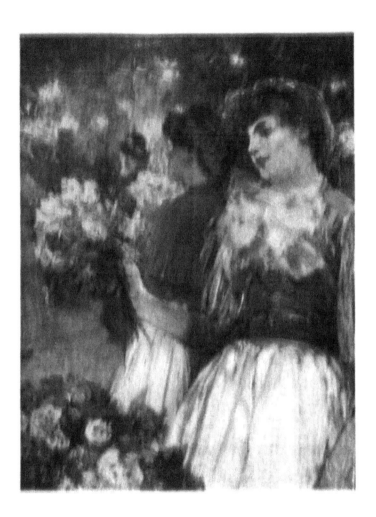

PEONIES
Owned by the artist

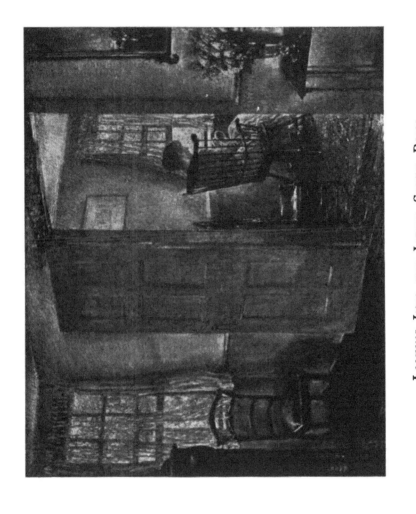

LOOKING INTO THE LITTLE SOUTH ROOM
Owned by the artist

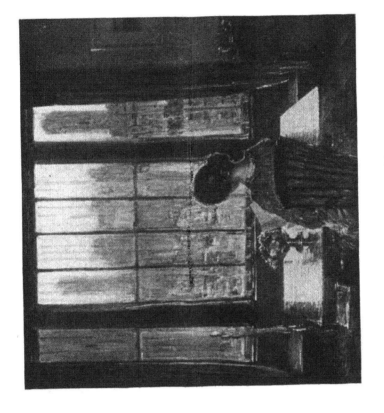

THE SKY SCRAPER WINDOW
On view at Macbeth Galleries

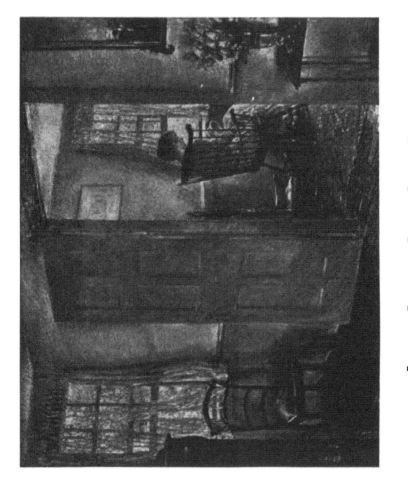

LOOKING INTO THE LITTLE SOUTH ROOM
Owned by the artist

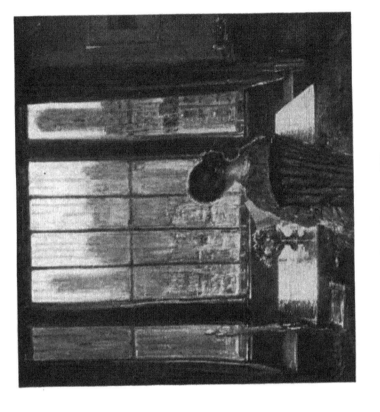

THE SKY SCRAPER WINDOW
On view at Macbeth Galleries

IN THE OLD HOUSE
Owned by Mrs. Emily J. C. Clark

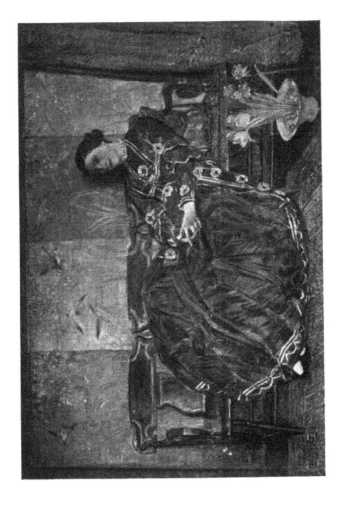

APRIL
Owned by the artist

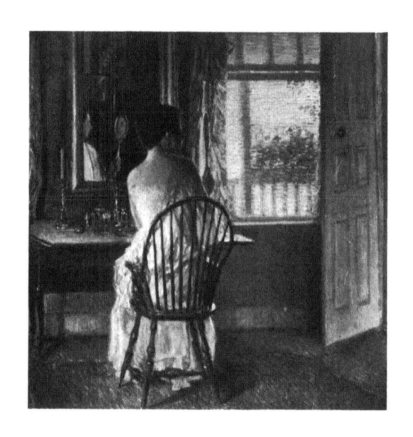

Morning Light
Owned by Mr. William A. Rogers, Buffalo, N. Y.

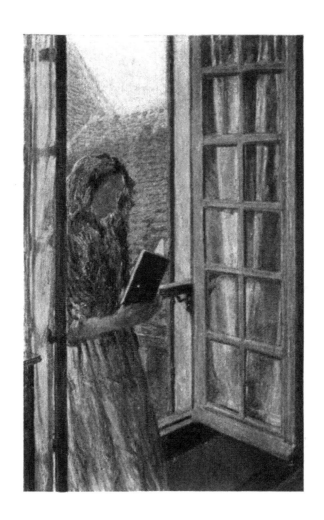

A WINDOW IN FRANCE
Owned by the artist

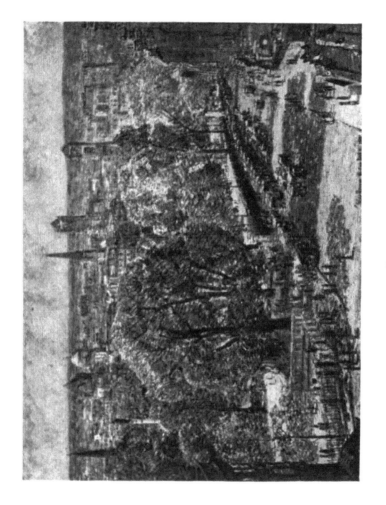

BOSTON
On view at Milch Galleries

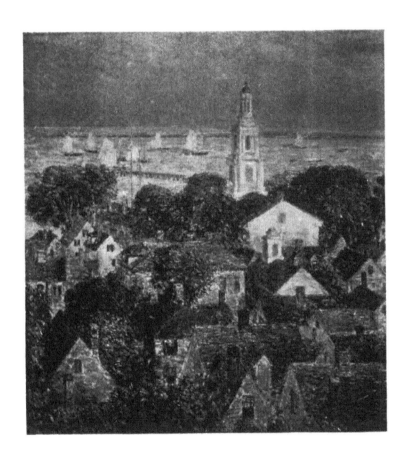

PROVINCETOWN
On view at Macbeth Galleries

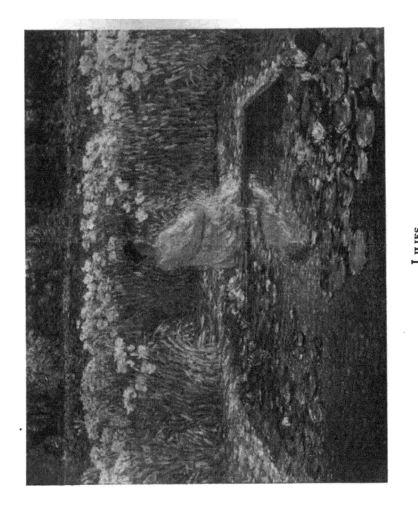

LILIES

Owned by Henry K. Pomroy, Esq., New York City

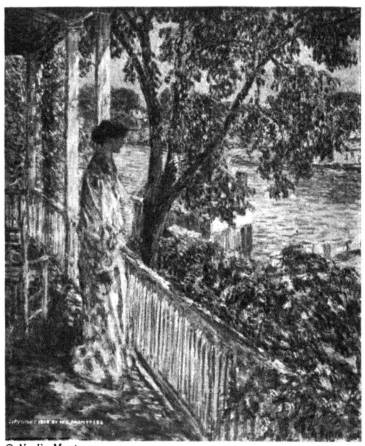

LISTENING TO THE ORCHARD ORIOLE
Owned by Stephen C. Clark

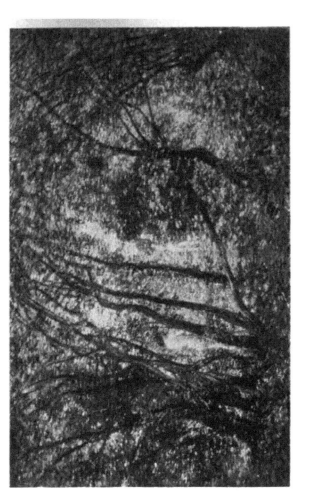

THE LITTLE JUNE IDYLLE
Owned by Miss R. B. Moore, New York City

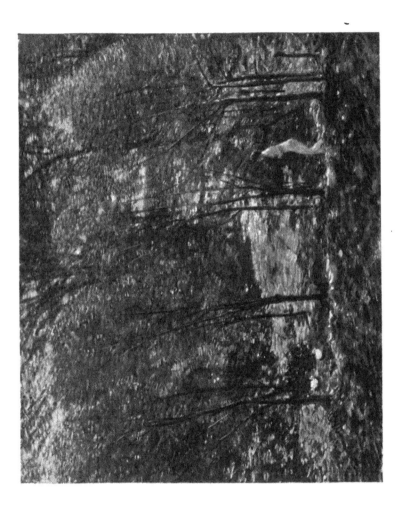

THE NYMPH WITH DUCKS
Owned by Duncan Phillips, Washington, D. C.

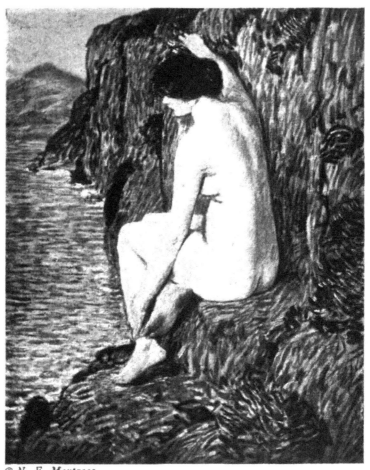

"LORELEI"
Owned by the Walters Gallery, Baltimore

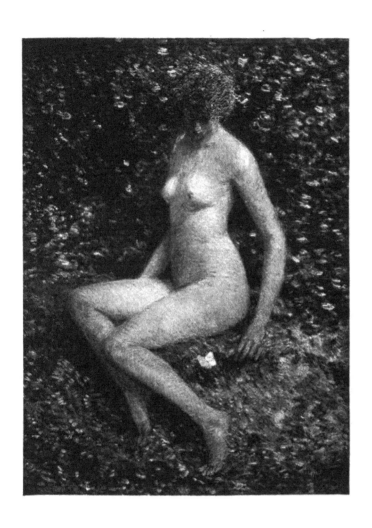

THE BUTTERFLY
Owned by Howard Young, New York City

BROAD COVE, ISLES OF SHOALS
Owned by Charles I. Baldwin, New York City

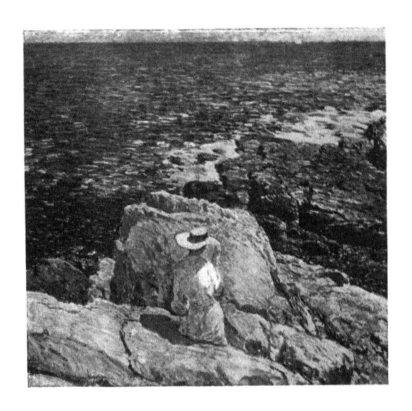

THE SOUTH LEDGES, ISLES OF SHOALS
Owned by Dr. Thomas A. Bennett, New York City

JUNE
Owned by the artist

MAY, FORT GEORGE
On view at Macbeth Galleries

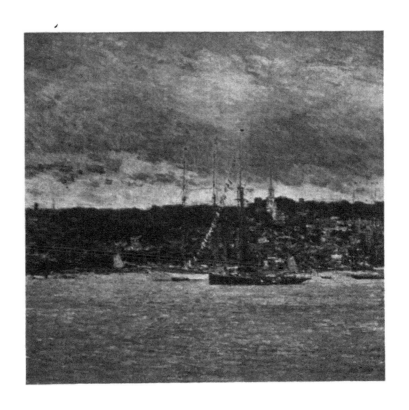

NEWPORT
Owned by David Gray

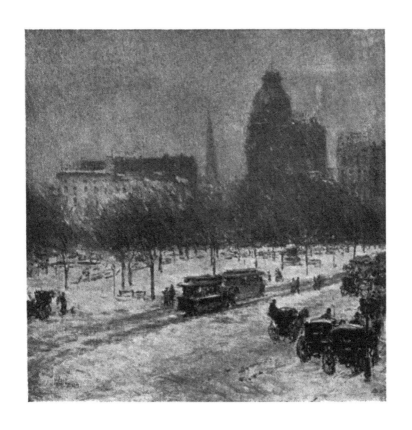

UNION SQUARE
Owned by George Barr McCutcheon, New York City

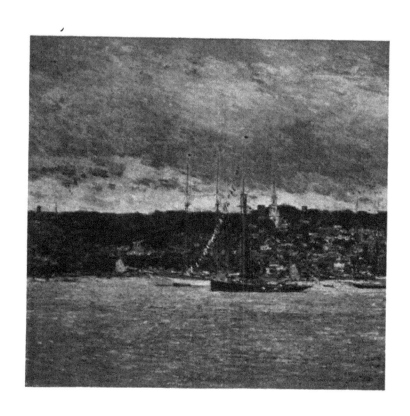

NEWPORT
Owned by David Gray

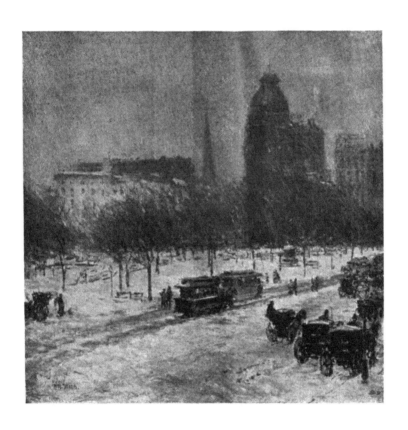

UNION SQUARE
Owned by George Barr McCutcheon, New York City

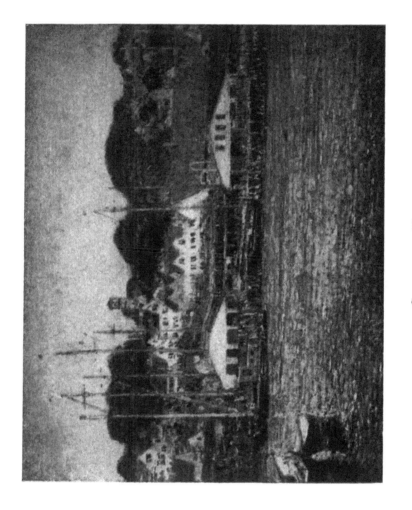

GLOUCESTER HARBOR

Owned by Hershey Eggington, Brooklyn

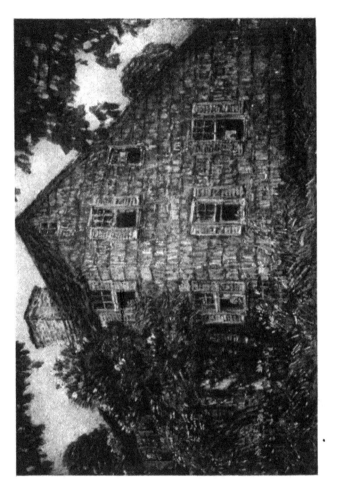

OLD HOUSE, EASTHAMPTON
On view at Macbeth Galleries

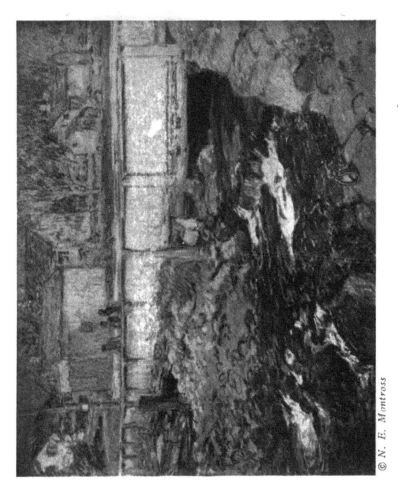

THE OLD BRIDGE AT COS COB
(Pastel)
Owned by Miss R. B. Moore, New York City

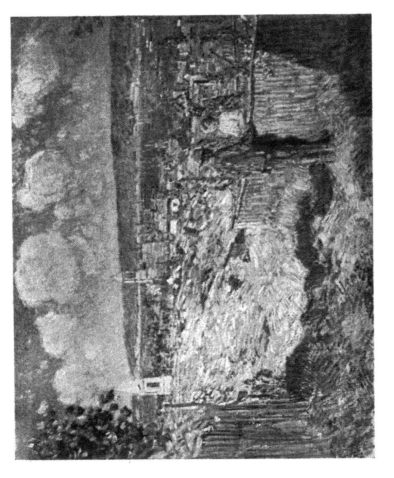

OCTOBER IN NEW ENGLAND, 1918
Dedicated to the New England 26th Division
On view at the Milch Galleries

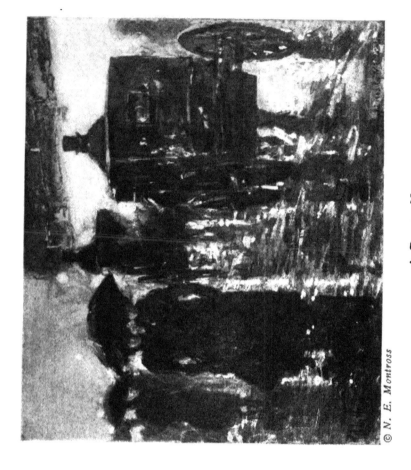

A RAINY NIGHT

Owned by Burton Mansfield, New Haven, Conn.

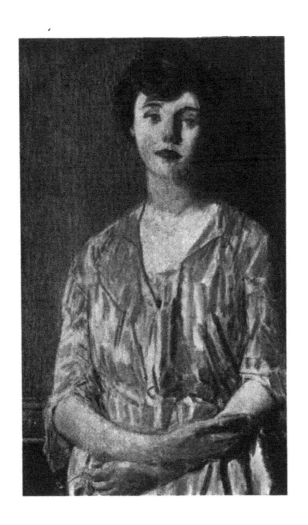

A STUDY
Owned by Miss R. B. Moore, New York City

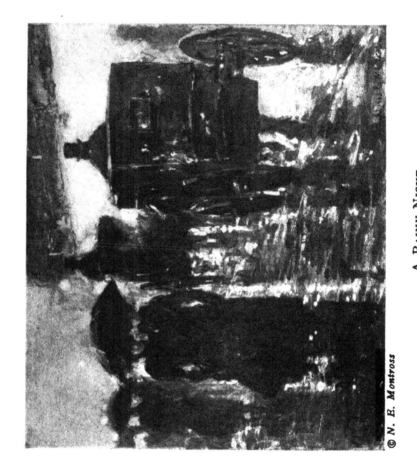

A RAINY NIGHT

Owned by Burton Mansfield, New Haven, Conn.

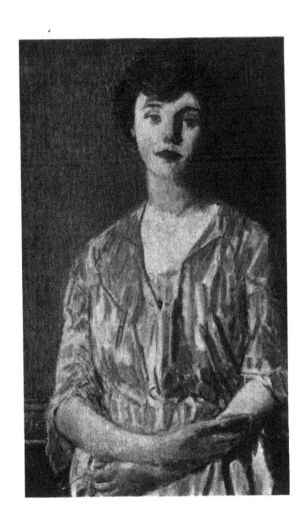

A STUDY
Owned by Miss R. B. Moore, New York City

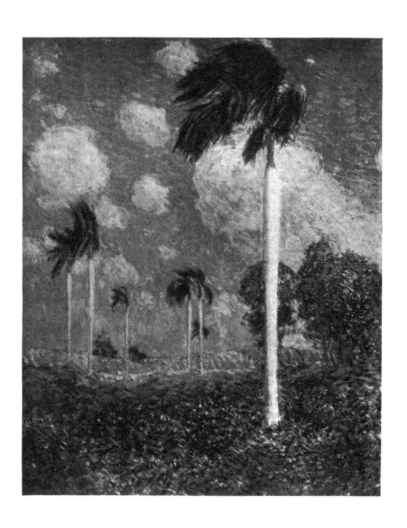

ROYAL PALMS, MELENA, CUBA
Owned by Horatio S. Rubens, New York City

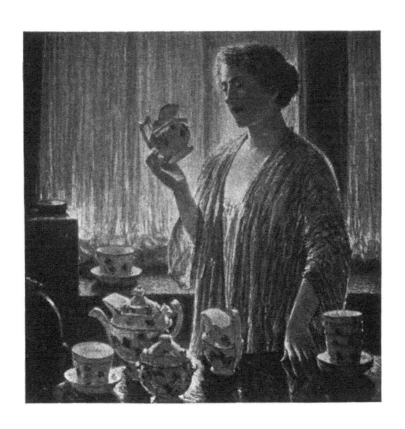

THE STRAWBERRY TEA SET
On view at Milch Galleries

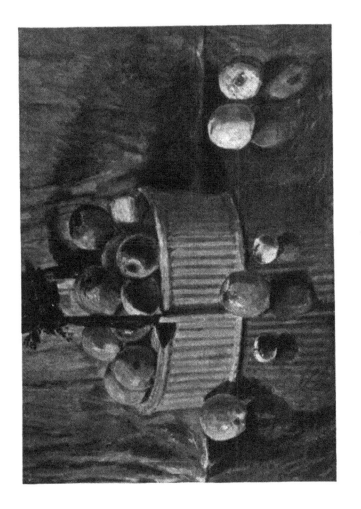

OREGON APPLES
Owned by the artist

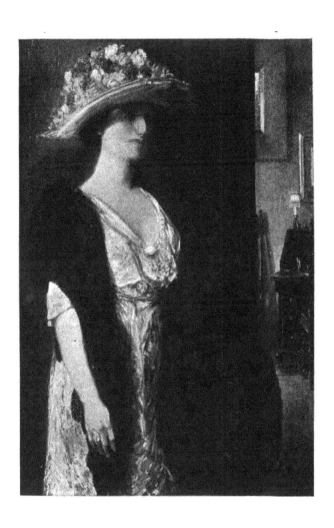

FIRE OPALS
On view at Milch Galleries

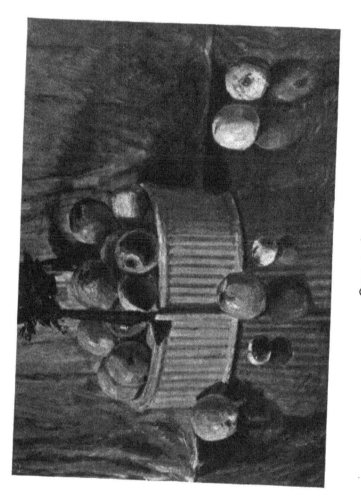

OREGON APPLES
Owned by the artist

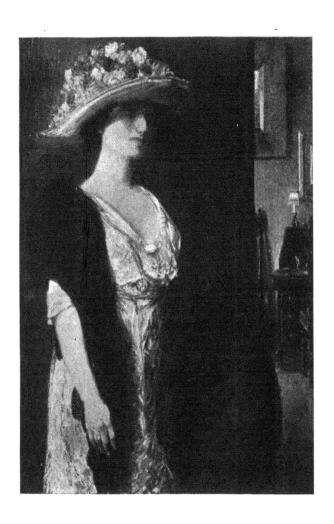

FIRE OPALS
On view at Milch Galleries

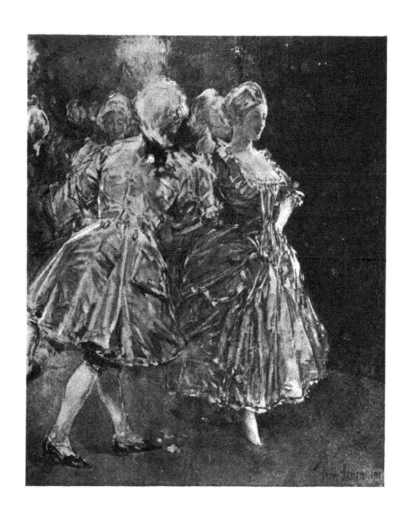

THE MINUET
(Water color)
Owned by Mrs. Marshall Field, Chicago

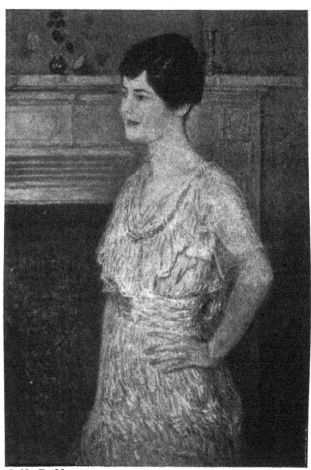

THE WHITE MANTEL

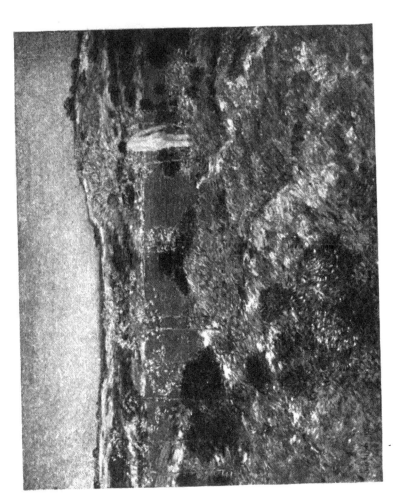

THE DUNE POOL

Property of H. W. Jones Estate, Kansas City

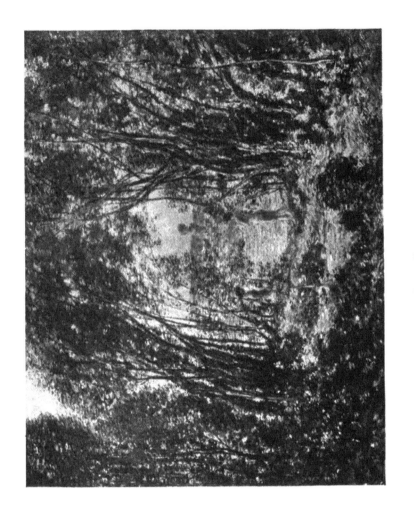

JUNE IDYLLE
(Smith College, Northampton, Mass.)

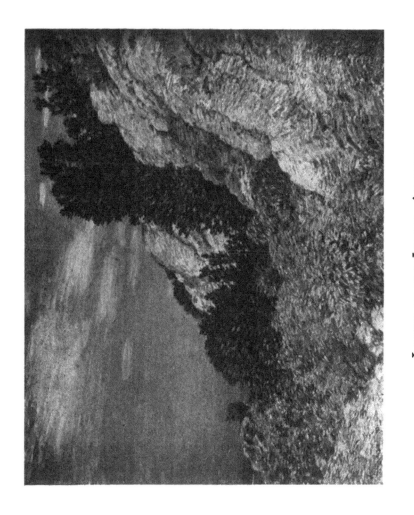

LAUREL IN THE LEDGES—APPLEDORE
Property of C. T. Palmer Estate

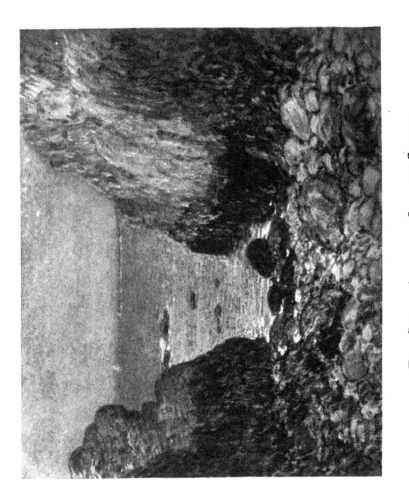

THE GORGE—APPLEDORE, ISLES OF SHOALS
Owned by Horatio S. Rubens, New York City

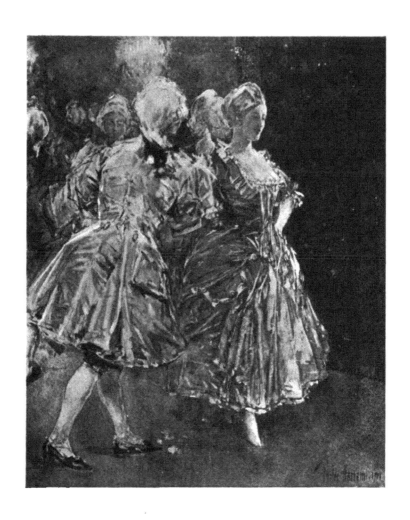

THE MINUET
(Water color)
Owned by Mrs. Marshall Field, Chicago

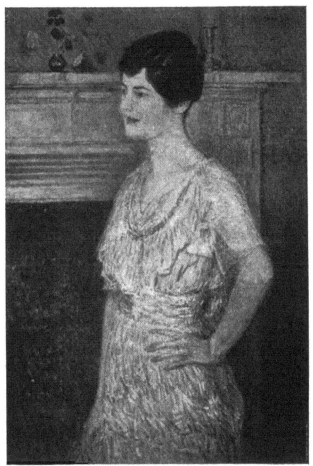

THE WHITE MANTEL

THE DUNE POOL

Property of H. W. Jones Estate, Kansas City

JUNE IDYLLE
(Smith College, Northampton, Mass.)

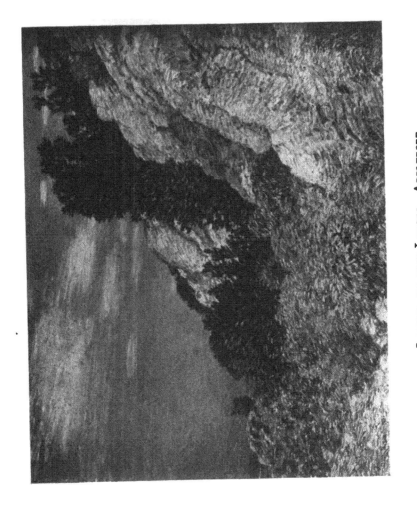

LAUREL IN THE LEDGES—APPLEDORE
Property of C. T. Palmer Estate

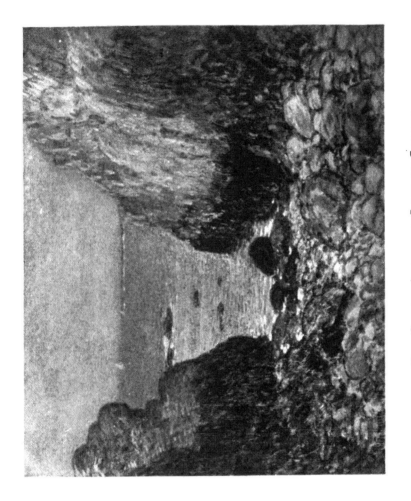

THE GORGE—APPLEDORE, ISLES OF SHOALS
Owned by Horatio S. Rubens, New York City

SUNSET IRONBOUND. BAR HARBOR
Owned by Miss Mary Moore, New York City

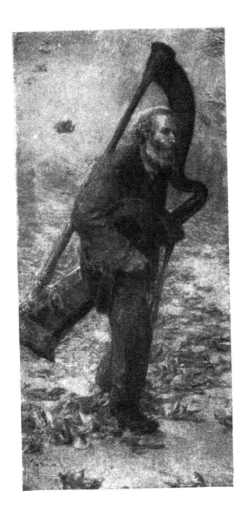

AUTUMN
On view at Milch Galleries

CHILDE HASSAM, 130 West 57th Street, New York, N. Y.
 Painter and Etcher, born in Dorchester, now part of the
 City of Boston, October 17, 1859.
 Studied in Boston and Paris.

MEMBER OF

NATIONAL ACADEMY OF DESIGN, New York—*Associate,* 1902
NATIONAL ACADEMY OF DESIGN, New York — *Academician,*
 1906
AMERICAN WATER COLOR SOCIETY, New York
NEW YORK WATER COLOR CLUB
BOSTON ART CLUB
TEN AMERICAN PAINTERS
PAINTERS-GRAVERS OF AMERICA
MUNICH SECESSIONISTS—*Corresponding Member*
SOCIÉTÉ NATIONALE DES BEAUX-ARTS, Paris—*Associate*
NATIONAL INSTITUTE OF ARTS AND LETTERS, 1907
AMERICAN ACADEMY OF ARTS AND LETTERS, 1920

AWARDS

At the Panama Pacific Exposition, Hors-concours, being awarded
 a gallery for the exhibition of a group of works.
Bronze Medal, Paris Exposition, 1889.
Gold Medal, Munich, 1892.
Medal, Philadelphia Art Club, 1892.
Bronze Medal, Columbian Exposition, Chicago, 1893.
Prize, Cleveland Art Society, 1893.
Webb Prize, Society of American Artists, 1895.
Prize, Boston Art Club, 1896.
Second Class Medal, Carnegie Institute, Pittsburg, 1898.
Temple Gold Medal, Pennsylvania Academy of Fine Arts, 1899.
Silver Medal, Paris Exposition, 1900.
Gold Medal, Pan American Exposition, Buffalo, 1901.
Gold Medal, St. Louis Exposition, 1904.
Clarke Prize, National Academy of Design, 1905.
Third Class Medal, Carnegie Institute, Pittsburg, 1905.
Lippincott Prize, Pennsylvania Academy of Fine Arts, 1906.
Carnegie Prize, Society of American Artists, 1906.
Third Prize, Worcester, 1906.
Sesnan Gold Medal, Pennsylvania Academy of Fine Arts, 1910.
Third W. A. Clark Prize, Corcoran Art Gallery, 1910.

Evans Prize, American Water Color Society, 1912.
First W. A. Clark Prize ($2,000), and Corcoran Gold Medal, Washington, 1912.
Altman Prize ($500), National Academy of Design, 1918.
Hudnut Prize, American Water Color Society, 1919.
Philadelphia Water Color Prize, 1919.
Altman Prize ($500), National Academy of Design, 1922.
The Gold Medal of Honor, Pennsylvania Academy of Fine Arts, 1920. This medal is awarded on an artist's achievement in the Fine Arts.
Gold Medal Art Club of Philadelphia, 1924.

REPRESENTED IN

METROPOLITAN MUSEUM, NEW YORK,
> *Isles of Shoals* and *Golden Afternoon, Oregon; The Brush House* and *Street in Portsmouth, New Hampshire.*

CORCORAN GALLERY, WASHINGTON, D. C.,
> *Northeast Headlands — New England Coast* and *New York Window.*

CINCINNATI MUSEUM,
> *Pont Royal, The Calker* and *House on the Place Lannion*

CARNEGIE INSTITUTE, PITTSBURG,
> *Fifth Avenue in Winter* and *Spring Morning,* also set of twenty-five drawings.

MUSEUM OF ART, TOLEDO......................*Summer Sea*

FINE ARTS ACADEMY, BUFFALO,
> *Church at Old Lyme* and *Brook Back of New Canaan.*

RHODE ISLAND SCHOOL OF DESIGN,
> *The Messenger Boy* and *Street Scene*

WORCESTER ART MUSEUM,
> *The Breakfast Room, New York; Yonkers from the Palisades* and *Sylph's Rook, Appledore,* and a group of water colors.

NATIONAL GALLERY, WASHINGTON,
> *Spring—Navesink Highlands* and *The Georgian Chair* (Evans collection), and *The Chinese Merchants* (Freer collection).

PENNSYLVANIA ACADEMY, PHILADELPHIA....*Cat Boats—Newport*
ART ASSOCIATION, INDIANAPOLIS........*Cliffe Rock—Appledore*
INSTITUTE OF ARTS, DETROIT,
> *Place Centrale* and *Fort Cabanas, Havana*

ART INSTITUTE, CHICAGO..........................*Contre-Jour*
MINNEAPOLIS INSTITUTE OF ARTS..............*Isles of Shoals*
BOSTON MUSEUM OF FINE ARTS.......*The Nymph of the Gorge*

Brooklyn Museum,
>View of Central Park and Magnolia Grandiflora and a group of water colors.

City Art Museum, St. Louis,
>Diamond Cove, Isles of Shoals, The East Window and The Fête of Lannion, Gray Evening.

The Hispanic Museum, New York City,
>Una Plaza—Sevilla and Puerte del Sol—Toledo (water color).

Art Club of Erie......................Evening Appledore
Tellfair Academy, Savannah....Brooklyn Bridge in Winter
Portland Art Association, Portland, Oregon,
>In the Harney Desert

San Francisco Art Museum,
>The Yachts, Gloucester Outer Harbor

PUBLISHED MATTER

International Studio, New York, January, 1916. "The Ambidextrous Childe Hassam"—Charles L. Buchanan.

Art in America, New York, June, 1920. "Childe Hassam" —Eliot Clark.

Whistler Notes and Footnotes and other Memoranda, New York, 1907. The Collector and Art Critic Co. Page 96, a note.

Brush and Pencil, Chicago, June, 1901. "Childe Hassam, impressionist"—Frederic W. Morton.

International Studio, New York, December, 1911. Childe Hassam—A Puritan.—Israel L. White.

Arts and Decoration, New York, October, 1915. "Who's Who in American Art."

Famous Painters of America, McSpadden. Dodd, Mead & Co., 1916.

Childe Hassam—A Note, by A. E. Gallatin, 1907.

International Studio—Frederick Price, 1923.

Milton Keynes UK
Ingram Content Group UK Ltd.
UKHW020848170124
436182UK00006B/233

9 781021 306999